WITHDRAWN

# BRONZES OF WEST AFRICA

# BRONZES OF
# WEST AFRICA

by

## LEON UNDERWOOD

LONDON/ALEC TIRANTI/1968

# CONTENTS

*First edition* 1949
*Second, revised edition,* 1968

PRINTED BY PORTLAND PRESS LTD., LONDON W.1
BOUND BY C. & H. T. EVANS LTD., CROYDON

MADE AND PRINTED IN THE UNITED KINGDOM
GB SBN 85458/090-5

# PREFACE

In *Masks* and *Figures in Wood* the art of West Africa was searched for the influence its styles and techniques have had on the art of Europe. But it was found that the principle of African art is synthesis, and so has nothing to compare with analysis—the aim of European abstract art. West African art was found to be pre-logically innocent of those 'abstractions' inferred in it by European intellectuals. Expression in African art aims at representing with religious humility the unseen power which nature reveals to man.

This third study, *Bronzes of West Africa*, gives us the opportunity of examining the assumed connection between West African art and the intellectual abstractions of Europe, and of finding it a heresy. Bini art is the unique example of the insubordination of rational sensation to intellectual form. In the hankering after 'abstract' form in modern art, the intellect with arrogant confidence attempts to storm the citadel of rational expression—to re-enter it by the tortuous path of psycho-analysis. This present study will show Bini artists emerging unsusceptible to an intellectual abstraction (earlier than our own, that is comparative measurement in the classical style they met at Ife). Bini art is an early example of the failure of the intellect to restrict the expression of rational emotion. In Bini art we see this example with intimate clarity—as distinctly as the details of the distant view seen

5

through a telescope. There was some temporising with the measured classical style before the Bini rejected it. During this period of temporising, the Bini was near to the achievement of fusing the two styles, but this was not to last.

The Bini readily adopted and retained the more intellectual (crafty) technique of bronze casting at Ife, for he accepted it as an expedient to advance his expression. This technique meant progress for mere chippers of wood—a means by which hard unyielding metal could be run fluid and frozen solid into forms modelled in wax! Metal promised him extended expression—as it has done for others, and yet continues to do.

The retreat of European art, in this century, from the dry bones of its late neo-classical tradition, resembles thus far the retreat of Bini art from the classicism of Ife. But we will not escape by this retreat until we understand African and other primitive art better. In order to reform our tradition so that it shall include all the art of the past, the eternal conflict between our rational and intellectual faculties must be brought before the eye of every man. For it is only when a past style happens to be in phase with our own position that it speaks to every man.

It is hoped that the brief text and plates of this book will help in a general understanding of the moods of the muses. This is needed before all great works in the idioms of the past appear coherent.

# INTRODUCTION

Not until after World War II did general interest awaken in these bronzes as evidence in a cycle of bygone style that was actually recurring in living art. European style had descended the ladder of decline and got stuck with intellectual realism, sauced-up with the polite sentiments of romance. The Impressionists had then turned away from photographic neo-classicism, and decline had proceeded to the Expressionist phase of Vincent Van Gogh and Paul Gauguin. And from this abyss, Van Gogh and Co. led the campaign of rescue, for the *avant-garde* who wished to go forward and could not do so. Rummaging over the styles of the past, in defiance of the cyclic nature of style, has gone on ever since. A similar relapse is seen to have occurred, in the bronzes of West Africa, between Ife and Benin.

The decline of Western Art since the Italian Renaissance has, in its final stages, sought to rehabilitate the appeal of style by emulating West African and other native styles. But the result has proved a failure, through Western inability to simulate the *belief* in primitive art. The style of West African art challenges the loss of integrity in Western art: it challenges those without that indivisible integrity of belief, essential to art, who have attempted to trade on primitive style.

The art of a culture in decline cannot adopt the style of another's belief. Rummaging among bygone styles in search of more life for the regeneration of old subject-matter is an illusory situation, a lost cause. There is a universal rise and fall in the pervading influence of technological know-how on style; in its exploitation of natural resource. In the wear and tear of cyclic renewal, the *spirit* of advance will come again by turning away from the *letter* of antecedent performances. It is hoped that the text of this revised edition will help the reader to an understanding of the moods of the visual muse; for without this, the phases of past styles cannot be realised in their connective evolution.

Bronzecasting was practised in West Africa at two principal historical centres, Ife and Benin. Of the bronzes of Ife and Benin we know little, except that they have slight associations of style and stronger associations of techniques. In this revision of the 1949 text, the technique of the *cire perdue* (waste wax) method of bronze-casting has been treated in the light of my experimental researches into the original practice in the Near East, 4,500 BC. For we suppose that bronze technology by the *cire perdue* process found its way into Africa from its source in the Near East; but by what connection and route, remains (at present) unclear. For while West African bronze-casting is strongly associated technologically with that of the Near East, in inspiration it departs from it; as also from the modern concept of *pure abstraction* in the Western decline.

Following my two previous volumes on the Art of West Africa; on *Figures in Wood*, and *Masks*, this study of the *Bronzes* examines the departure which works in bronze make from the traditional wood-carving style and its animistic subject-matter.

ACKNOWLEDGMENTS

Acknowledgments and thanks for permission to photograph and reproduce works are due to Aderemi, the Oni of Ife, The Trustees of the British Museum, Capt. G. H. Lane Fox Pitt-Rivers, The Royal Scottish Museum, The Nigerian Government, M. Charles Ratton of Paris, and Messrs. Walter de Gruyter & Co. of Berlin.

9

# BRONZE TECHNOLOGY

Bronze-founding arose in the Near East to liberate stone toolmaking from the Neolithic limitations of unique production: whereas in Africa, iron had come to the toolmaker before bronze arrived, possibly about the tenth century; and the impact of bronze-casting in West Africa was almost exclusively on sculpture. Its traditional forms had had but the short duration of wood in a tropical climate: and the technology of bronze-casting—the melting of the metal and its solidification in a prefabricated mould—offered a lengthy durability for the sculptor's traditional forms.

At Ife and Benin this new technique had something of the same effect that ultimately resulted from the demonstration of the potential of electricity by Michael Faraday in nineteenth-Century Europe: Bronze, a sculptor's medium, that could be melted into a fluid stream to replace the deftly modelled wax originals in fireclay moulds, had the promise of electricity in it:

> Man's mind but recently engulfed
>   The hidden nature of metal,
> And condensed it in his being
>   As the earth congeals its ores.
> Since the spirit of Faraday
>   Alloyed itself with the metals,
> They have bridged many rivers
>   With their span of iron lace,
> Wound the spinnerets of cranes,

The ancient practice of bronze-casting by the waste wax or *cire perdue* process spread in Europe for the foremost purpose of casting arms and munitions of war. The original practice permitted only unique production, as it continued for works of art. But there is no doubt that the toolmakers and armourers were the principal innovators in the practice of reproduction for military purposes. Let us say that early development was shared by artists, armourers and toolmakers.

For African bronzes, many functional tool-forms were raised to the rank of subject-matter: lamps, stools, bells, locks, and keys: flasks with hinged lids surmounting ceremonial staffs (pl. 47a). Occasionally, lesser forms in other metals were combined with the bronze, usually by being 'cast-on'. In Benin heads, insets of the pupil of the eye (plates 24-27 and 30-33) were often made in iron. This was done by inserting iron pellets as pupils into the waxen eyes, to be picked up and held in the surrounding bronze. Iron was regarded with special magical significance on account of its superior efficiency in toolmaking. (See plate 64a, copper and iron inlays.)

The normal usage at Ife is precisely that employed for casting tools in bronze and for castings of precious metals, in Europe and the Near East in the third

*The author engraved these lines on the base of his cast and cut-brass figure *The New Spirit*, in 1933; as a tribute to our foremost metallurgist, Michael Faraday.

millennium B.C. Its use at Ife and Benin is best described in general terms as: modelling the core in fireclay, to a size about one-quarter-of-an-inch short of the final surface all over; drying the clay core and covering it with beeswax a quarter-of-an-inch thick. This wax coat receives all the final detail-modelling. A round hole is cut out of the wax at the top of the head (plate 19). The head is then tilted as in Fig. I

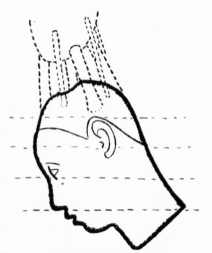

Fig. I.—*Conjectured angle of pouring and of system of runners and vents for casting Ife head No. 6.*

and the pouring-cup and runners attached to the top (dotted lines); the whole is then invested in fireclay to a thickness of several inches all over, up to the rim of a pouring-cup. When dry it is then put on to a fire to

12

burn out the wax; the fireclay core of the head being held in place by its union with the jacket-investment, through the fireclay, at the hole in the head and the column of the neck. In those heads (pl. 19) where no hole in the top of the head was made for this purpose, the method was to drive iron nails through the wax into the core to serve the same purpose of supporting the core in location when the wax was burnt out. Now the bronze was poured; and on cooling, the fireclay investment was removed by soaking in water.

At Ife the tilt of the head was so arranged as to give the flow of bronze down over the face area the surest chance of being solid and free from fault by gas or air bubbles; any faults occurring at the back being more readily dealt with by repair. The head in plate 2 was poured at the tilt shown in Fig. I, as a tide-line caused by a halt in the pouring reveals. Several minor faults in some heads are seen to have been repaired—some by 'burning-in', so called. This was done by remodelling the missing part in wax on the bronze. Investing the bronze again inside and out with fireclay; burning out and pouring the repair piece when the heat inside was high enough to fuse the edges of the fault with the molten metal.

The first Ife head of high classical style was brought to Europe by Leo Frobenius of the German Inner Africa Expedition in 1910; at a time when the first Post-Impressionist Exhibition opened in London. This Frobenius head was similar to the 'Olokun' head (plate 1); so-called because it was kept by the priests of Ife in a grove sacred to the Olokun. There is a mystery surrounding the original; for the head I saw at Ife in 1945 was, I discovered, a reproduction (head on extreme left, pl. 19). Frobenius who took the original head from Ife also dug up a number of small terracotta heads, of quality similar in many cases and finer in some than the bronze heads reproduced in these plates. Yet there was no identical resemblance in any of them. Twenty-eight years later, more bronze heads were dug up in the foundations made for a new house within the precincts of the Oni's palace at Ife. There is no record of how many were found then, but twenty are now known to exist; eleven of these are shown with the reproduction of the Olukun head on pl. 19; and there is some reason to believe that there were others.

The first 'Olokun' head, found by Frobenius in the Oni's possession—of which the head on the left in pl. 19 is a reproduction—is said to have been unearthed

by a priest long before Frobenius appeared on the scene. It was periodically put to ritual use, and buried again after each occasion in order to avoid angering the spirit of the sea-divinity it represented. Its present whereabouts is not known. The copy of it in the Oni's possession, first suspected by me, has since had its falsity established (MAN, 1948, I). The second, similar head (plate 1), now in the British Museum, was discovered in 1938. The known heads are: 16 in possession of the Oni of Ife, two which went to the U.S.A. and have since returned, and one in the British Museum. In 1948 the Oni sent his 16 heads to the British Museum for exhibition in the King Edward VII Gallery: and I photographed them when unpacked on the floor (plate 19). The head on the left is the copy mentioned above; even in this small-scale photographic reproduction its texture betrays it.

# HISTORY, BENIN

Early visitors to the city of Benin observed a few bronzes in private shrines outside the palace, in the houses of nobles and court officials: but nearly all the important Benin bronzes came from the palace of the Oba. This was a structure of mud and wood, laid out in halls and open courtyards surrounded by covered ways. The principal hall was lined with wooden panels, with bronze plaques nailed on to them (plates 50 to 60).

Ling Roth in 1903, in his work *Great Benin, its Customs and Horrors*, quoted from the account of an early Dutch visitor:

> A man might write more about this town if he were allowed to see it, as you may our towns at home; but it is not permitted here, but forbidden and prevented by one who is always given to attend upon you, to show you the right way, so no one is allowed to go through the town, which they say is because a stranger should not lose his way, but nevertheless one may not go boldly just as one pleases.

Ling Roth adds that this restriction on European visitors was maintained to the last: and he speculates that the chiefs rightly feared that once a European got a footing he would soon become master of the country, as was his awkward way.

Commander Bacon, in *Benin the City of Blood*, narrates the political background to the destruction and looting of Benin by the British punitive expedition

under Admiral Sir Harry Rawson in 1897, avenging the massacre of a small deputation despatched to Benin City from Lagos by the Governor in 1896. The expedition-leaders brought to England almost all the art of Benin in bronze, ivory and wood. Most of it was dispersed in auction sales, between the British Museum; the Pitt-Rivers Museum, Farnham, Dorset; and the *Museum für Volkerkünde*, Berlin; and these museums issued the first European publications on the art of Benin: all weighty quasi-scientific scholastic illustrated catalogues: expensive and of limited circulation. But the first notable speculative commentary on the bronzes was in Ling Roth's work already quoted.

# STYLES

Apart from the internal evidence of the style itself, we know nothing of the history of the bronze and terracotta heads of Ife, beyond the belief that the bronzes of Ife precede those of Benin. It seems most likely that the artists of Benin learnt the technique of bronze-casting from the sculptors of Ife; for, as we have remarked, the connection between Ife and Benin bronzes is more considerable in technique than in style.

The pre-classical Roman and its post-Roman renaissance in territories around the Mediterranean spelt a long and arduous development. From these Mediterranean centres, there has been a general and continuous collation, digestion and distribution of technology and style in artefact and art. At the change-over of the technological and economic structure of a culture, from an old basis to a new, style undergoes mutation: from the *supra-natural ideal*, through the *imitative real*, to delve into *abstraction* beneath the surface of natural appearance. Somewhere along this line lies all the art of the past: whether it partakes of the central movement, or of its delayed or reversed peripheral ripples.

The High Classical ideal twice recurring, in Greece and in Renaissance Italy, is the interdependent counterpart of the Romantic or Primitive element: their difference lies in the different intellectural reference of

their forms to the natural model. In the currency of their respective codes, the *classical* attempts not to idealise the invisible but to sublimate the visible: whereas the *primitive* measures proportion by the emotional associations of the subjective import of the form, in the local culture. The Greek classical style was based on natural proportions of comparative measure, idealised by athletic symmetry: the prior, primitive, romantic style depended upon the emotional appeal of form, for its proportions; delving beneath the surface-appearance of nature; probing for some ideality, in powers unseen, or unmeasurable by logical comparison.

Each of these styles has its limits. There is no purity, no rest between them; style ever moves away from one pole and towards the other on its circular course. The intellectual European and the intuitive African have to approach each other's outlook. This cannot be done by transplanting as the modern European abstractionists have tried; and failed for want of belief or conviction in the effort. There is plenty of virtuosity in their efforts—plenty of *the letter* in the technique, but none of *the spirit*; since they are without its parent-belief.

From these examples of Ife and Benin, the European tiro of exotic styles should have much to learn. The subject-matter of belief is all that can breed style. Without this inherent source, all imitation comes to no more than passing virtuosity; a negative contribution. As William Blake saw, 'Art and Religion are one' and brook no substitutes: but here we have not

19

space to pursue this.

Wherever the emotional influence on form is totally inhibited, the subjective judgment of proportion is utterly suppressed. Alienated from the poetry and subjective transports of the ideal, the form surrenders to the objective. The evolution of the ideal of natural form in Europe was stripped of the ideal element by the Romans: but before the Romans of the first centuries A.D., the naked naturalism that they employed has been clothed by an idealism in the selection of natural proportions.

Authority on the Renaissance art of Europe regarded the primitive Italian painters' style as 'sub-barbarian'. But then, at the beginning of this century, before Western decline was commonly recognised, the followers of art could not see—as we can—the need for our worn intellectual judgment of proportion to return to its classical strength: intuitive variation from strict measure is needed to bend style to an ideal of nature.

The African has no need to feel embarrassment at the European term of *primitive* applied to his trad-itional style. The distinction of primitive style has been much confused by a muddled comparison of primitive art with 'child art,' which has no relevance to the matter. There is no *true primitivism* in the European child's nursery-style of drawing. The European child has been taught, by subliminal encouragement, to absorb an intellectual generalisation of form: squares, circles, noughts and crosses. And in

his pictorial expression, he begins to build images with these abstractions.

Neither it is appropriate to ascribe *magic* as the motive of West African traditional art; for the West African carver aims at representing the invisible powers at work beneath the surface of nature, by an elaborate synthesis of natural forms. His image is no *idol*, but an *icon*.

To those of us who can read the meaning of style on its cycle in the past, the art of Ife and Benin represents a local movement on the periphery, reversing the general movement of style in the centre.

For the present, assessment of the age of the Ife heads remains a matter of association; by seeking resemblances in Europe, in the Renaissance revival of Greek classicism. The Greek style, in the Italian Renaissance, became suffused with spiritual overtones from the subject-matter of Christian belief: this spiritual emotive content, conveyed in the handling of the fleshy parts of the face, is especially noticeable in the heads in pls. 1, 2, 3, 17.

The only non-realistic convention in the Ife heads is the provision for representation of facial hair in abundance, by holes cast in all but two of them in pls. 13, 14, and 17. Elsewhere, in Europe, no bronze heads make such provision. This featuring of *beards*, among a beardless race, presents another problem of interpretation.

The variable proportions of these heads represent personal likenesses, there seems little doubt: apart from

**21**

their differences of handling, ascribable to the individual variations of the artists' styles. These variations pervade each and every style extant in art, but are more distinct in the Classical styles by virtue of the comparison of measure.

Here in the bronzes of West Africa is the record of the establishing of European style in the territory of Ife, and the gradual recession from European style at Benin. The cultural roothold of European style, imported into Africa, had no succession outside the Oni of Ife's territory. By viewing plates 23-26 and 34, 35, this intellectual infusion of measured form can be seen diminishing in stages. The connective influence of style between Ife and Benin is seen most in pl. 23, by comparing it with pl. 17. The imagery of this intrusive style at Ife was confined to the heads of rulers or their delegates, to serve a subject-matter of the divinity of these alien kings. Whereas the Bini bronze-smiths caught on to the Ife techniques of fine casting, which they could understand, they let go of the influence of its sophisticated style. The indigenous belief of the Bini found more varied imagery to communicate its animistic subject-matter: the net was cast wider, to cover much more than the personal likenesses of rulers and their delegates. Whereas the art of Ife had idealised the natural appearance to convey the sublime or *supra-natural*, the art of Benin gravitates towards the *sub-natural*: the obscure forces operating beneath nature's visible surface.

Clearly this style of Ife was intrusive in West Africa.

'Greek' flashes to mind, as its generic source. The influence seems not to have come direct, for the Greek ideal conflicts with the realism demanded of portraiture. But the Colonial Greek styles that remained, pursuing that practice of portraiture predominant

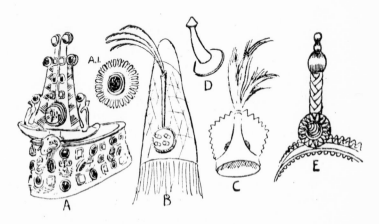

Fig. II.—*A: silver crown of Nubian king, found in tomb (4th to 6th century A.D.) at Ballana (after Emery).*
*A1: Crest from Nubian horse collar.*
*B: Bead crown of the Oni of Ife (Adamiluyi).*
*C: Bead crown of the Ogoga, Adewumi—*The crown pleases me*—of Ikerre, 1945.*
*D: Wooden crest, of phallic significance, worn on the forehead of Berber chiefs.*
*E: Crest on crown (?) of the Olokun head of the Oni's; it suggests an original beadwork or plaited grass form.*

in the Italian Renaissance, could have been the source of this intrusion at Ife, on the periphery of the Classical world. Perhaps here was an invitation from the prelogical primitive style of West Africa to the

23

logical classical style, to co-operate: on some local political grounds, lost to record.

Benin Art, although independent of Ife in style, does seem to have temporised with it for some time. But this fusion of two outlooks was not to last. The archetypal beauty of the early heads from Benin (pls. 23-26) yet holds to an *ideal* of form above the reality of nature. Perhaps it would be simpler to call it a *highly selective representation* of the real. Whereas pls. 27, 28 and 29 mark three varied representations of a sub-natural order of meaning, beneath the optical: three attempts to visualise the *unseen*. These examples in the Bini style are somewhat comparable to the earliest Italian primitives: but whereas the latter were on the way up to the High Renaissance, these Bini sculptures are moving away from it: their meaning seeks expression by *abstraction* away from the real. The supra-natural intellectual ideal, in the heads of Ife, was gradually reversed to the sub-natural unseen which is indigenous in West African religion and art wherever practised.

There is no documentary evidence of any very close or intimate exchange of technology between the peoples of Ife and Benin: but the know-how of technological advance travels fast, and the distance between these two cultural centres is short. In the early heads and bronze plaques of the Oba's palace, the bronze-casting practice of the highest order of technical skill remained with the Bini. Finally this coarsened, until in the Thirties it was studied to some extent and recovered.

The Bini bronzes document a general exchange of influence, between the intrusive style in the new medium and the traditional forms of the old—wood, ivory and occasionally stone. There is a conflict of cultural interests; of traditional and intrusive subject-matters. The traditional forms, conditioned by the old materials, had a structural influence on the forms modelled in wax for bronze-casting: and conversely, the forms convenient to wax-modelling were influential on carving in ivory, wood and stone. Material challenged style; beadwork, basketry and weaving lent their character to wax-modelling; and from the bronze forms, these characters were re-translated into wood and ivory.

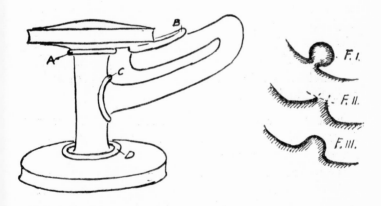

Fig. III *shows this influence of wax forms in stone-carving (quartzite). For example the moulding at* A, B, C & D *are not stone forms as at* FII *and* FIII. *The form of* FI *is a wax form, rendered in stone with difficulty. This implies that there was no quartzite carved at Ife before the introduction of the cire perdue process used in Ife heads.*

Realism is most marked in the treatment of the Bini heads (pls. 23, 24, 25). The poise of the dome of the skull over the face is seen to recede in pl. 25. The proportion of the skull to the facial features later loses its realistic relationship. This stylistic simplification of the head in Benin bronzes gives the best comparison of the divergent intellectual-intuitive judgments underlying the two styles. And it suggests a dynasty of rule at Ife which terminated and departed; having sown some influence in the style and technology of bronze-casting at Benin.

The typical beak-like nose form of the Benin heads (A, B, C, D etc., in Fig. IV) is an influence of the core-form of Ife on the styles of Benin. The technical demand of fine casting was an even thickness of wax over the prefabricated fireclay core-forms. It requires a bronze-sculptor's eye to appreciate the practised skill that made these cores at Ife, without upsetting either the thickness of the eventual bronze or the proportions of individual likeness.

Procedure was almost as exacting as fetish to the African. He paid meticulous attention to the states or stages it demanded of him in bringing his work to some projected form. Each state is achieved with but little deviation. The Bini artists would therefore take over the *cire perdue* process of casting bronze, from Ife, in a neat sequence of stage-operations: *categorical procedure* is the technical textbook of the craftsman for whom memory served instead of literature. His first

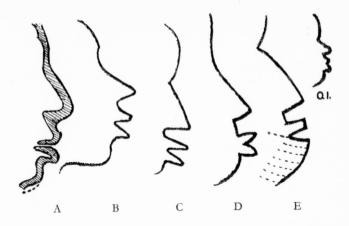

Fig. IV—*Comparative degrees in the prognathous character of fireclay cores of Benin heads (B, C, D, E) with reference to Ife head (A—plate 12), and profile of the Oni Adamiluyi of Ife (O.I.)*

deviation from rigid procedure would naturally be in modelling the final wax coating. The Ife type of core-form would therefore be modified only gradually as the Bini style advanced. The core-form and the wax form would become more identical as he acquired his superlative skill, in making perfect bronze castings of one-sixth the thickness of the Ife heads.* The Bini artistic resource was more naturally inclined to the use of the underlying core forms of Ife bronzes, in the formulation of Bini style. The same high regard for

*The Bini bronze sculptors took over the casting of bronze, and cast some extremely thin heads (as pl. 28) one-sixth of the thickness of the Ife heads. In the cast of the Bini head in pl. 26, the thickness of the metal varies from one to three millimetres, which permits but little difference between fireclay core-form and its coat of modelled wax.

27

naturalism in the ear as for all features is maintained at Ife. While the classical idealism in the Ife heads seems to have influenced the Bini bronze sculptors for some time, they never copied the naturalistic treatment of the ear. (Pls. 16, 17).

# CONCLUSION

Speaking of those bronzes which were not purchased by the British Museum, Ling Roth says:—

> From what I can ascertain, the bulk of these has been acquired by the Germans, and it is especially annoying to Englishmen to think that such articles, which for every reason should be retained in this country, have been allowed to go abroad. Not that I blame the Germans in the least for what they have done, but it is only one example of their alertness and our apathy.

Typical of the numerous smaller parcels here and abroad are the Beasley collection and the small collection of Admiral Rawson recently purchased by the Nigerian Government.

Politically, the Ancient World around the Mediterranean was divided into diverse and separate sovereign states: but these frontiers were crossed by technology and therefore by style. Envoys, traders, consuls in the train of conquering armies, carry technologies and styles outwards from the centres of their origin: the whole of the Ancient World was a network of these reciprocal influences.

The sword of conquest imposes alien forms, but does not cut deep enough to uproot the indigenous. In cast metal especially, style is fluid: its forms as changeable as the medium itself. The currency of style transmutes into the currency of trade (as coinage)

and back again as occasion serves. Sculpture in wood is but ephemeral in the climate of the dark continent. Terracotta and stone, however, survive to record the vicissitudes of style in Africa.

'Nubia is the highway between darkest Africa and the Mediterranean' says W. B. Emery in *Nubian Treasure*. The *cire perdue* process of bronze-casting may have taken this highway into Africa: to arrive at Ife in the style of Roman or Renaissance portraiture, perhaps as late as the fourteenth century.

Alongside the upper Nubian Nile, the styles and techniques of many invaders commingled: Emery discloses, in a few plates, the diverse influences of Egypt, Byzantium, Greece, Crete, and Rome. Considerable classical influence indeed is evident in Nubian art: but nothing precisely identifiable with the style of Ife. Ancient denizens of the Upper Nile, the Blemyes and the Nobatae, were sufficiently skilled in bronze-founding to have cast the Ife heads: but there is nothing in Nubia to indicate that they could have *modelled* them.

The earliest known Egyptian sculpture in beaten copper is the statue of Pepi (about 4,500 B.C.), 5 ft. 9 ins. high. But neither style nor technique connect this work with that of Ife: its sensitive hieratic realism is not that of individual portraiture: its method of manufacture was almost certainly by beating and not by casting. Sculpture of copper beaten over a yielding bitumen core was extensively practised in Sumeria before 3,000 B.C., and the technique could have reached

30

Africa at any time. But African sculpture of beaten or applied metal, such as that of Dahomey, (Pl. 62) is usually made of the sheet-metal of European traders. Metal is applied to wooden sculpture widely in West Africa, especially in Benin and Abomey, Dahomey. The Bakota of the French Congo applied metal to the wooden figures of their ancestral spirits set up over graves. (See pl. 22, *Figures in Wood* also in pl. 31 a similar figure of the Fang tribe). Ironworking, extensively used for weapons, was also used for a limited mode of sculpture called *ematon*: a ritual staff embodying various simplified animal-forms.

In Southern Nigeria, at Tada and Jebba, bronze figures were cast on a scale of near life-size: plates 21 and 22 show two of these from Tada; one in the Ife style, one in the Bini. This suggests that the schools of Ife and Benin spread their influence by trade and migration, and through itinerant sculptors. From the Igbo tribe in Ibo territory comes a hoard of decorative bronzes of lesser sculptural significance. From the Andoni Creeks in Southern Nigeria comes another hoard of bronzes (now in the British Museum): including some exceptionally fine decorated objects, and the finely (thinly) cast figure in plate 61. Apart from the Ashanti gold weights in plate 64, we have not space for the more recent brass figures of Dahomey and the small bronzes of the Cameroons. These other West African centres of metal sculpture did not produce enough to qualify as *schools*, centres of influence.

# SHORT BIBLIOGRAPHY

Aderemi,
Oni of Ife.
Article in NIGERIA, No. 12, 1937 (the Oni's account of the antiquity of his people's ancestors).

Bacon, R. H.,
Commander, R.N.
*Benin the City of Blood* (by the Intelligence Officer to the Punitive Expedition—1897).

Berenson, Bernhard.
*The Decline of Art*, 1907 (from *The Italian Painters of the Renaissance*, 1930).

Cellini, Benvenuto.
*Memoirs* (the author's account of casting his large *Perseus*).

Emery, Walter B.
*Nubian Treasure*, 1948 (popular account of discoveries at Ballana and Qustal).

Fagg, W. B., and
Underwood, Leon.
*An Examination of the so-called 'Olokun' Head of Ife, Southern Nigeria*, MAN., 1948, Article 1.

Fletcher,
Major Benton.
*Vanished Cities of Northern Africa*, Hutchinson and Co. (no date) (a brief and incomplete account of the complex comings and goings of style invasions between the civilisations of the Mediterranean and Africa), graphically describing the present remains there.

Frobenius, Leo.
*The Voice of Africa*, Vol. 1, 1913.
*Das Unbekannte Africa*, 1933 (the author's account of discovery of the 'Olokun' head, and many terra cotta heads reproduced).

Lucas, A.
*Ancient Egyptian Materials and Industries.*

Luschan, Felix von
*Die Alterrümer von Benin*, 1919 (on the collection in the Museum für Völkerkunde, Berlin; preceded in 1901 by a smaller volume on the collection in the Stuttgart Museum).

Pitt-Rivers,
Lieutenant-General.
*Antique Works of Art from Benin*, 1900 (illustrated catalogue of Benin collection in the Pitt-Rivers Museum, Dorset).

Quibell, J. E., and
Green, F. W.
*Hierakonpolis*, 1902 (plates and notes of Quibell's discoveries in 1898, including the copper statue of Pepi).

Read, C. H. and
Dalton, O.M.
*Antiquities from the City of Benin*, 1899 (British Museum).

Talbot, P. Amaury.
*Life in Southern Nigeria*, 1932.

Underwood, Leon.
*Abstraction in African and European Art* (an article in THE STUDIO, Dec., 1948).
*Figures in Wood of West Africa*, Tiranti, 1947.
*Masks of West Africa*, Tiranti, 1948.

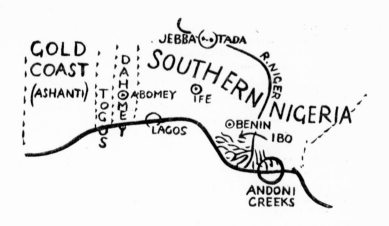

# INDEX AND
## DESCRIPTIVE NOTES TO PLATES

*(The Ife heads are known by their excavation numbers, quoted on the plates, and, excepting two, are all approximately life size. In these notes the styles of the heads have been classified under four headings—* OLOKON, MOORISH, OBALUFON-EGYPTIAN, NEGRO. *The classification may be taken as an indication of different workmanship and period).*

1. IFE, Head. Slightly under life size. *British Museum.* Called *Olokun* on account of its resemblance to the so-called *Olokun* head discovered at Ife in 1910. One of the two Ife heads in America is of this type.

2–3. IFE, Head. Ex. No. 9. *In possession of the Oni of Ife.* A fine example of a type which is also represented by three others shown on plates 4, 5, 12, in which the features are of a Moorish cast.

4. IFE, Head. Ex. No. 11. *In possession of the Oni of Ife.* The straight cylindrical necks, of which this head has the longest, were so formed for fastening on to a wooden post.

5. IFE, Head. Ex. No. 12. *In possession of the Oni of Ife.* Closely resembling No. 9 (Plate 2) in type.

6.   IFE, Mask known as the *Obalufon*. 90% copper. *In possession of the Oni of Ife*. The type to which this conforms is of a different cast of features—more Egyptian. The slits beneath the eyes indicate its use as a mask in some sort of ceremony. Plates 7, 8, 9, 10 are of a similar type.

7.   IFE, Head. Ex. No. 8. *In possession of the Oni of Ife*. Similar in cast of features to the *Obalufon* mask.

8.   IFE, Head. Ex. No. 7. *In possession of the Oni of Ife*. The patina of the face has been darkened into an indigo blue, possibly because the head was mounted on a body to give a realistic representation of the sitter. It is of the same racial type as the *Obalufon* mask. Plate 6.

9.   IFE, Head. Ex. No. 15. *In possession of the Oni of Ife*. A large, finely modelled and cast head. The modelling is particularly sensitive in the fleshy parts of the face: *Obalufon* type.

10.   IFE, Head. Ex. No. 14. *In possession of the Oni of Ife*. The most finely-tooled of the heads. The *Obalufon* type to which this head belongs appears in this example strikingly Egyptian.

11.   Another view of No. 14 (Plate 10), in which its leaning to Egyptian in style is most visible.

12.   IFE, Head. Ex. No. 1. *In possession of the Oni of Ife*. A fragment consisting of face and part of skull. The ability to render individuality meticulously in portraiture is seen well in this profile.

13.   IFE, Head. Ex. No. 3. *In possession of the Oni of Ife*. This head and that on Plate 14 bear closest resemblance, in racial type, to the *Olokun* (Plate 1). Both these, as well as that on Plate 17, are without holes about the chin and may therefore represent females.

14.   IFE. Head. Ex. No. 6. *In possession of the Oni of Ife*. Compare this with head of the same type in Plate 13, to appreciate rendering of individual features in heads of the same racial type.

15.   IFE, Head. Ex. No. 2. *In possession of the Oni of Ife*. This head and those on Plates 17, 18 (*a* and *b*) are of a negro cast of features. Note the rendering of the bony ridge of the brow.

16.   MISS ADEREMI, Daughter of the Oni of Ife, 1949

17.   IFE, Head. Ex. No. 4. *In possession of the Oni of Ife*. The resemblance to the Oni's daughter is closer than just racial resemblance.

18*a*.   IFE, Head. Ex. No. 10. *In possession of the Oni of Ife*.

18*b*.   IFE, Head. Ex. No. 5. *In possession of the Oni of Ife*. No. 10 is the most heavily damaged (crushed) of the heads; both are of the same type as those on Plates 15, 17.

34

19. GROUP OF IFE HEADS. Nos. 1, 2, 3, 4, 6, 7, 11, 12, 14, 16, 17. Showing their comparative sizes. On the extreme left is the reproduction, in the Oni's possession, of the so-called *Olokun* head.

20. IFE, Half figure. Ex. No. 13. *In possession of the Oni of Ife*. The figure is in the style of the *Olokun* heads, and is rather less than half life size. The motif on the hat is a variation of that of the *Olokun's* (E., Fig. III).

21. TADA, Figure (Ife school). Preserved at Tada, Southern Nigeria, as a sacred object. Rather more than half life size. In portraiture and its modelling technique, this figure is to be associated with the Ife heads.

22. TADA, Head and shoulders of a figure (Benin school). Preserved at Tada as a sacred object. About three-quarters life size this, one of seven sacred bronzes of Tada, in modelling style and technique, is to be associated with the work of Benin.

23. BENIN, Head; known as *The Princess*. Life size. *British Museum*. Considered to be of the earliest period of Benin work: in a style which is therefore closest to that of Ife.

24. BENIN, Head; of early style. *Pitt-Rivers Museum, Dorset*. In this type of head (and on that on Plate 25), a fine appreciation of anatomy in the fusion of the separate forms of skull, face and neck, seems to be due to Ife influence.

25. BENIN, Head; of early style. *Royal Scottish Museum, Edinburgh*. Similar to that on Plate 24, but finer modelling.

26. BENIN, Head. *Pitt-Rivers Museum, Dorset*. A most skilfully cast head. This, and a somewhat similar head in the British Museum, vary in thickness not more than from one to three millimetres.

27. BENIN, Head; three-quarters life size. *British Museum*. In this head, which is of the spirit-type (a representation of a spirit), the influence of Ife is seen to be diminishing.

28. BENIN, Heads. *Pitt-Rivers Museum, Dorset*. Compare *a* to the head of Tada figure (Plate 22). In *b*, emphasis on the eye ball is similar to the steatite figures of Sierra Leone.

29. BENIN, Head; 6¾ins. high. *Museum für Völkerkund, Berlin*. This representation of a spirit is achieved by the great romantic freedom in rendering the expression of transport.

30. BENIN, Head; 12ins. high. *British Museum*. This and the head shown on Plate 31 are examples of the numerous " choker " heads, so-called on account of the high coral collars of Benin court dress.

31. BENIN, Head; 20½ins. high. *British Museum.* Similar to that on Plate 30, but of more elaborate style and probably of later date.

32. BENIN, Helmeted Head; 11ins. high to crown of head. *British Museum.* Increasing formalism of perhaps still later date.

33. BENIN, Helmeted Head; 14ins. high. *British Museum.* Similar to that on Plate 32, in style. Possibly a representation of the thunder god, Shango. The long point to the top of helmet—omitted in the reproduction—is as tall again as the head; see Plate 54.

34. BENIN, Hornblower; 26½ins. high. *British Museum.* In type and period, this figure must find a place close to those of Plates 24 and 25.

35. BENIN, Hornblower. *British Museum.* Detail of Plate 34. In comparing the style of this figure with Plates 24 and 25, it will be seen from the head that it is an early work.

36. BENIN, Figure. *Pitt-Rivers Museum, Dorset.* Figure of a priest (?), the style of which is seen departing further from Ife than the figure on Plate 34.

37. BENIN, Figure. *Pitt-Rivers Museum, Dorset.* A figure associated with the cult of hand-worship of Benin. Of late development in style.

38. BENIN, Prisoner Group; 13½ins. high. *British Museum.* All figures in this work face one way—typical of Benin figure composition.

39. BENIN, Group; 22ins. high. *Museum für Völkerkund, Berlin.* Seemingly a priest, with attendants. Connected with the cult of the thunder god, Shango. Holding, in the right hand, a staff, and in the left hand a celt—regarded as a thunderbolt.

40. BENIN, Cock; 20ins. high. *British Museum.* Of the several cocks known, this is the finest in its expression of the bird's character. Rather over life size.

41. BENIN, Portuguese Soldier; 18ins. high. *British Museum.* One of several of this subject. They are all of a similar spiral or all-round composition, not of the front-and-side-view composition of African subjects, as in Plate 34.

42. BENIN, Mounted General (?); 24ins. high. *British Museum.* This, and the one on Plate 43, represent the best of several works of this subject, but this is distinguished for the active posture of the halting mount.

43. BENIN, Mounted General (?); 18ins. high. *Nigerian Government Collection.* The passive posture of the mount is the usual one in works of this subject.

44. BENIN, Mounted Warrior. *Pitt-Rivers Museum, Dorset.* The posture of rider and mount reminiscent of that on Plate 42.

45. BENIN, Mounted Group. *Pitt-Rivers Museum, Dorset.* A small casting without core. Probably Yoruba: that is not far from Benin, and under its influence.

46. BENIN, Masks. *Pitt-Rivers Museum, Dorset.* It is recorded that these small bronze masks were suspended at the belt. *a* has the bridge of the nose inlaid with copper and the pupils of the eyes with iron; *b* the pupils of iron and the spots of other metal.

47. BENIN, Flask on top of Staff; 2ins. diameter, and figure on *ematon* top. *a, British Museum; b, Pitt-Rivers Museum, Dorset.* The hinged lid to the flask on *a* is decorated with a leopard. The unremoved runner of a repair is seen at the waist of the central figure. The figure *b* from the *ematon*— a staff-like structure of ceremonial use—is associated with the cult of hand-worship of Benin.

48. BENIN, Pendant. *Pitt-Rivers Museum, Dorset.* For personal adornment: the loop for suspension on the cap of the Portuguese rider.

49. BENIN, Pendant; 5¼ins. high. *British Museum.* Similar to that on Plate 48. A curious staff with double hook occurs in each.

50. BENIN, Archer and Bird plaque; the plaques are all about 18 ins. high. *Museum für Völkerkund, Berlin.* This is of exceptional character and merit, in that its composition is based on an oblique arrangement. Few of the very numerous plaques depart at all from a vertical and parallel arrangement of forms in their composition.

51. BENIN, Portuguese, Leopard Hunting. *Pitt-Rivers Museum, Dorset.* This fragment of a plaque is distinguished for its action in profile, as most of the plaques are represented towards the spectator.

52. BENIN, Figure plaque. *British Museum.* Single figure plaques occur infrequently.

53. BENIN, Leopard Hunters, plaque. *British Museum.* An example of the usual frontal presentation of the subjects in Benin plaque compositions. The curious fir-cone-like helmets are numerous.

54. BENIN, The Oba and his Hand-supporting Attendants, plaque. *British Museum.* Here a three-quarter view presentation of the attendants is employed to explain their correct posture of kneeling to support the hands of the Oba.

55. BENIN, Entrance to the Oba's Palace, plaque. *British Museum.* The ridge and shingle roof to the Oba's Palace is seen. The entrance is guarded by shield and fan bearing attendants.

56. BENIN, Drummer, plaque. *British Museum*. The rosette on the drummer's forehead is similar to that on the hat of the *Olokun* head of Ife, a detail motif occurring frequently in Nubian ornaments.

57. BENIN, Two figures, plaque. *British Museum*. A noble or court official with square bell of Benin on his chest is raising his shield in ceremony.

58. BENIN, Court Official, plaque. *British Museum*. Sword bearer with lesser attendant ringing sistrums. Symbols such as in this (top right corner) are frequent in the plaques, and may represent a palm or the sun.

59. BENIN, Mounted Oba or Noble with Hand-supporting Attendants, plaque. *British Museum*. The Oba's helmet in this plaque is similar to that of the head, Plate 33. These restrained plaques of lower relief give the impression of being early work.

60. BENIN, Animal Sacrifice, plaque. *British Museum*. The animal of sacrifice is detached from the plaque in its relief. In a plaque of similar subject in the Pitt-Rivers Museum, Dorset, the animal is in the same relief as the figures, and though cruder in modelling, appears to be earlier.

61. ANDONI CREEKS, Figure (School of Benin) approximately 16ins. high. *British Museum*. A finely cast figure (from 1 to 3 millimetres thick). Its appliqué style of wax modelling associates it with Benin work.

62. DAHOMEY, Lion; approximately 15ins. long. *In the possession of M. Charles Ratton, Paris*. The lion from Dahomey is best described technically as appliqué metal sculpture: an ancient practice in Summeria and Egypt. It is carved in a hard wood and covered with numerous thin plates of silver which are hammered into close contact with the carved wood and fastened down with silver pins.

63. Bronze hunter from the Lower Niger acquired by the British Museum 1952, height 14½ins. The hunter is shown with an antelope draped over his shoulders, a bow in his left hand, a hunter's fetish in horn swung over his shoulder, a quiver on his back, and his dog in front. Structural support for the mass on thin legs was provided, with indifference to anatomy, by an elongated foot, on a right leg down to the knee only.

38

64. ASHANTI, Gold Weights; *a*, 3¾ins. High. *British Museum. b, 2½ins. high, in possession of the author.* These two core-less castings have been included for comparison as representative of the many small castings of which the Ashanti and Baule gold weights are most numerous. The two figures of *b* are cast separately and riveted together at the base. This piece is a good example of the many small core-less castings of the Ashanti gold weight type produced by the Yorubas and others.

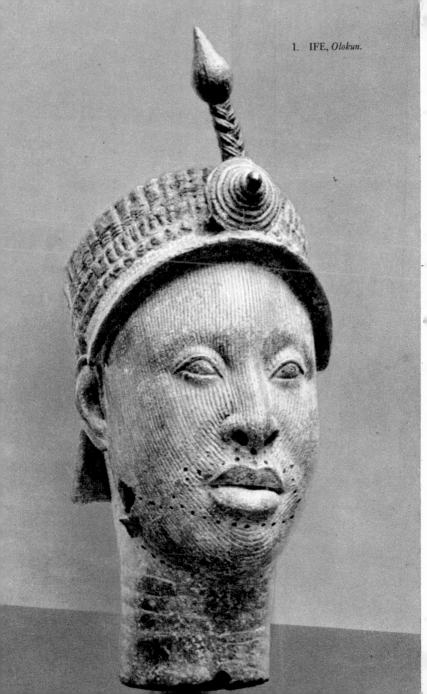

1. IFE, *Olokun*.

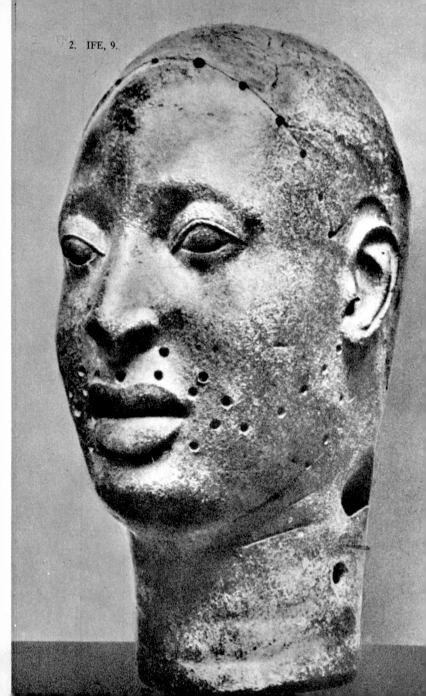

2. IFE, 9.

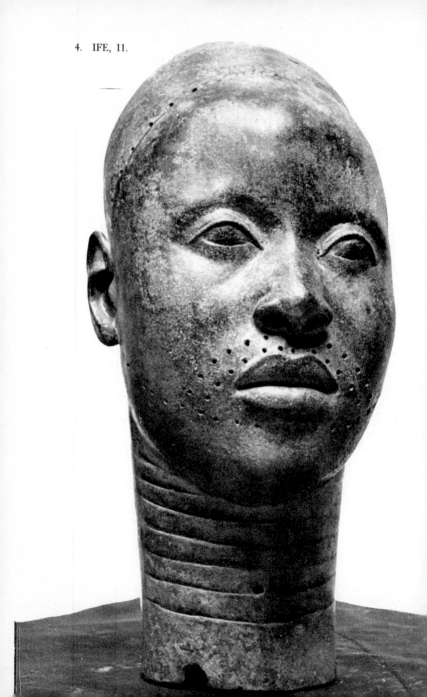

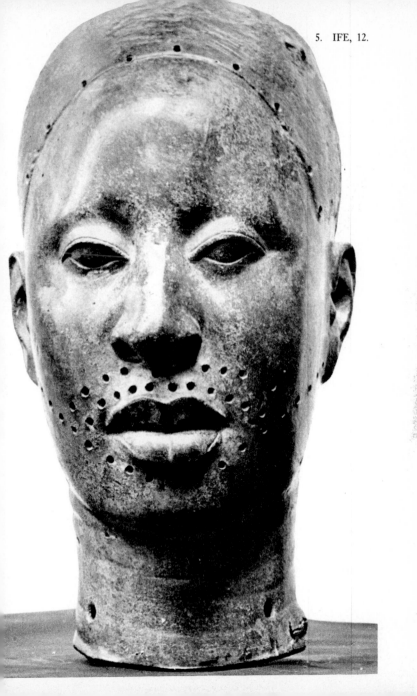

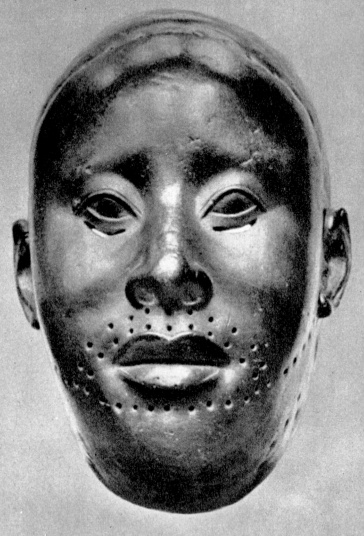

6. IFE, *Obalufon.*

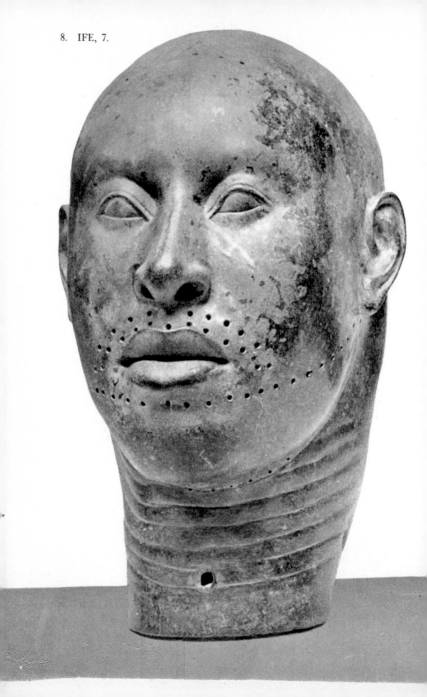

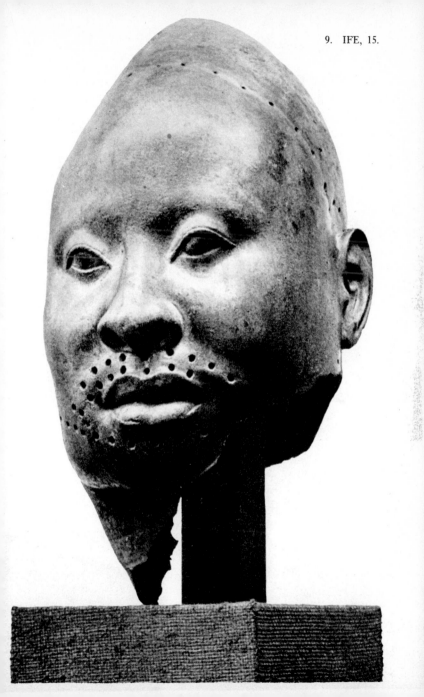

10. IFE, 14.

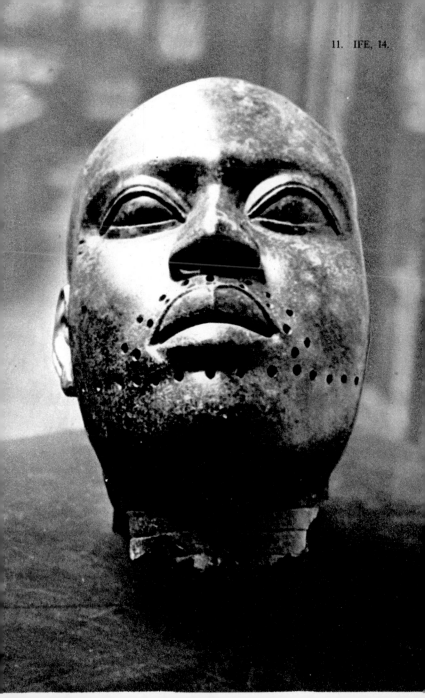

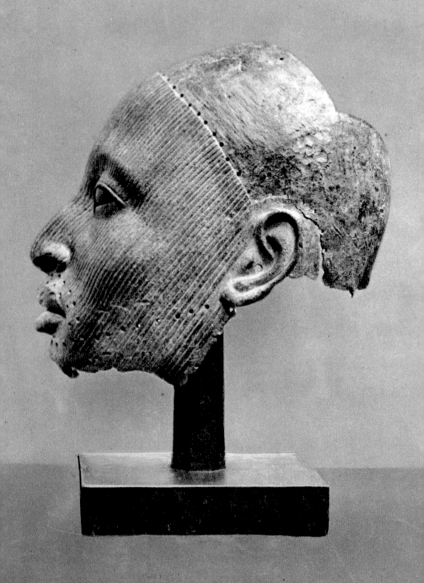

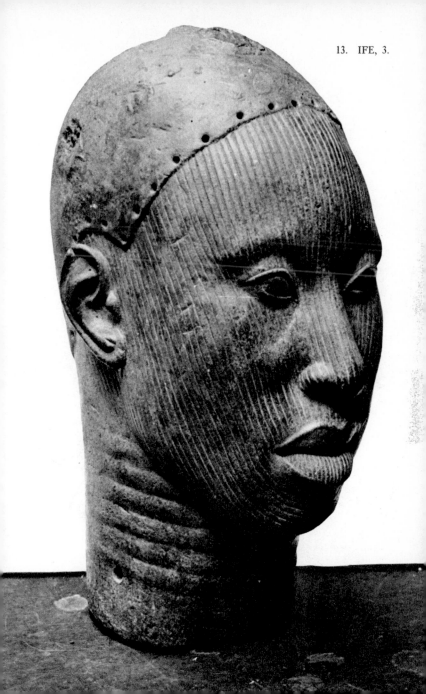

14.  IFE, 6.

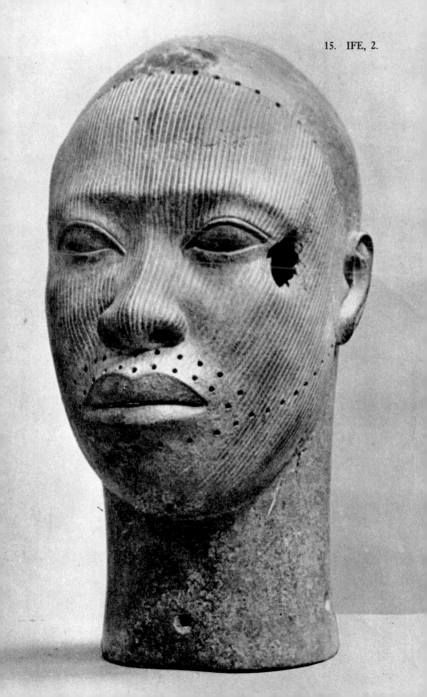

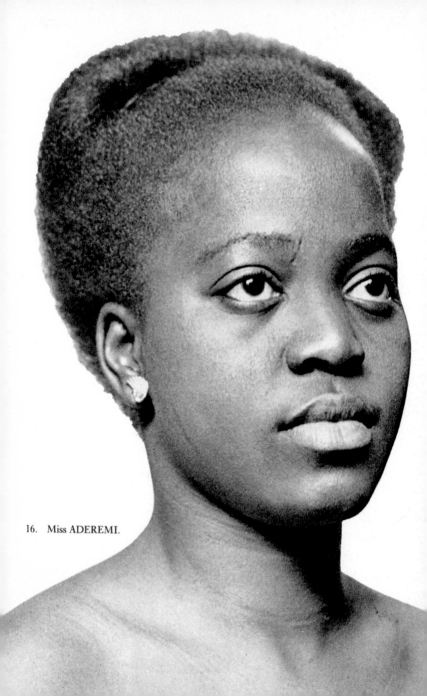

16. Miss ADEREMI.

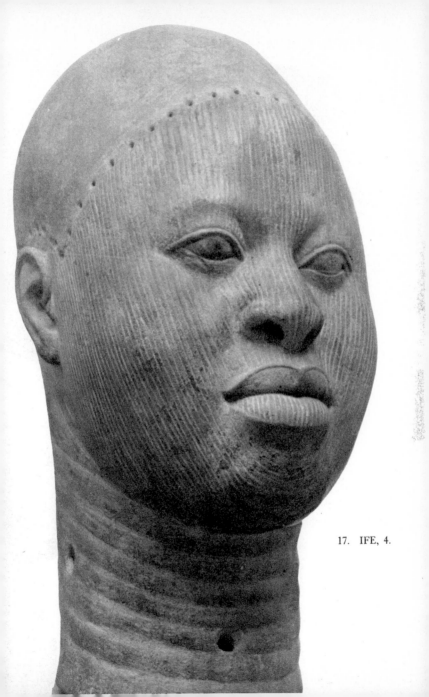

17. IFE, 4.

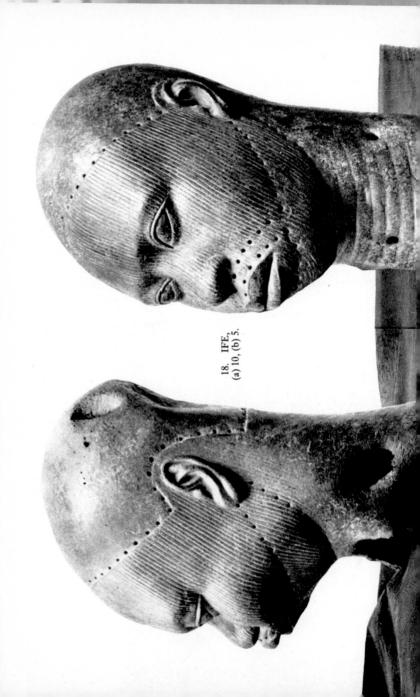

18.  IFE,
(a) 10, (b) 5.

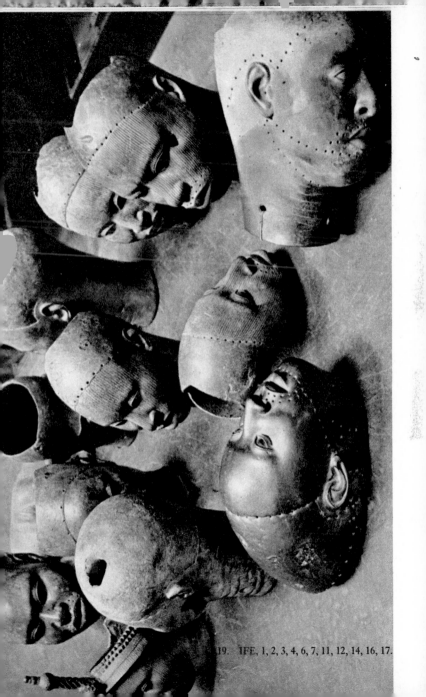

19. IFE, 1, 2, 3, 4, 6, 7, 11, 12, 14, 16, 17.

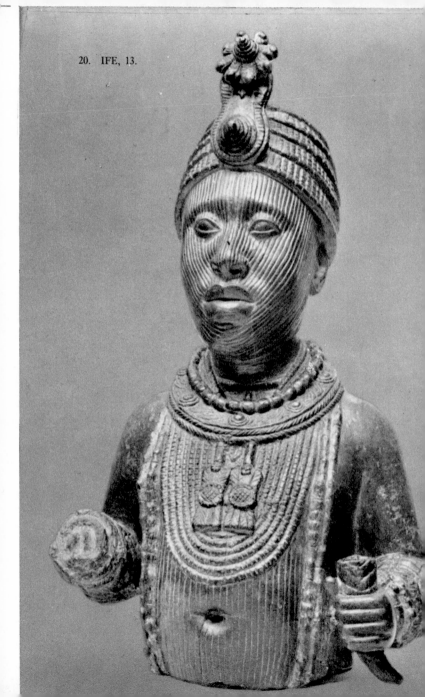

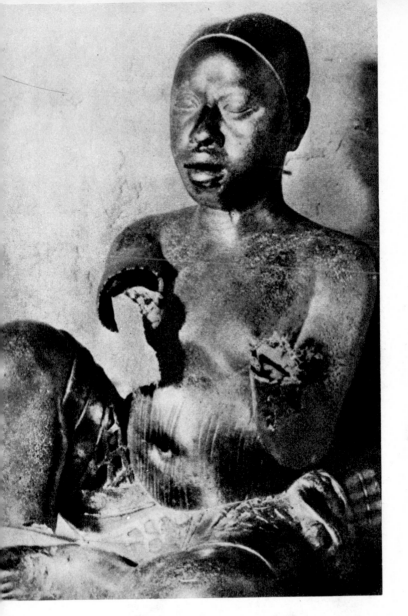

21.   TADA (Ife school).

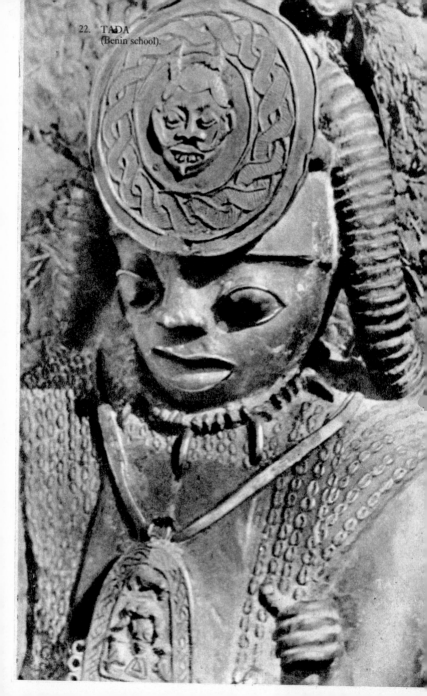

22. TADA
(Benin school).

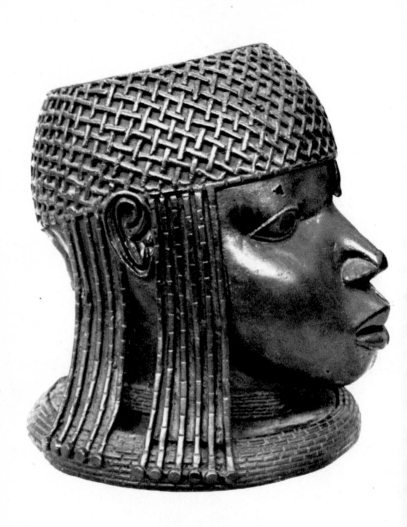

24. BENIN.

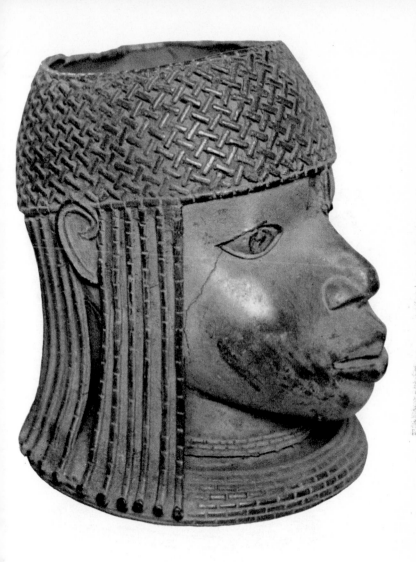

25. BENIN.

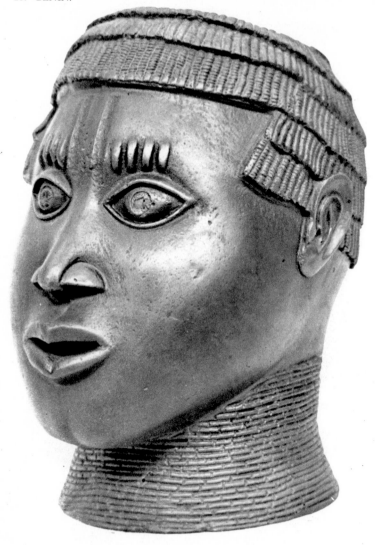

26. BENIN.

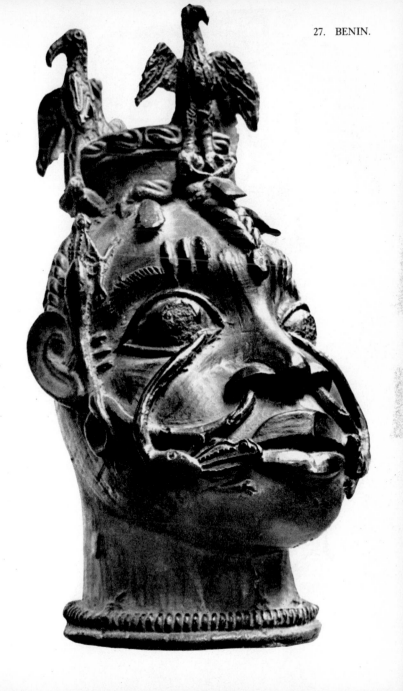

28. BENIN.

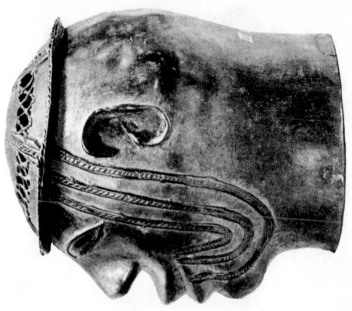

29. BENIN.

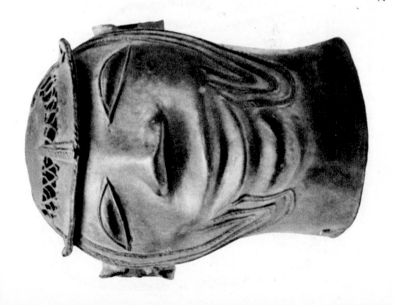

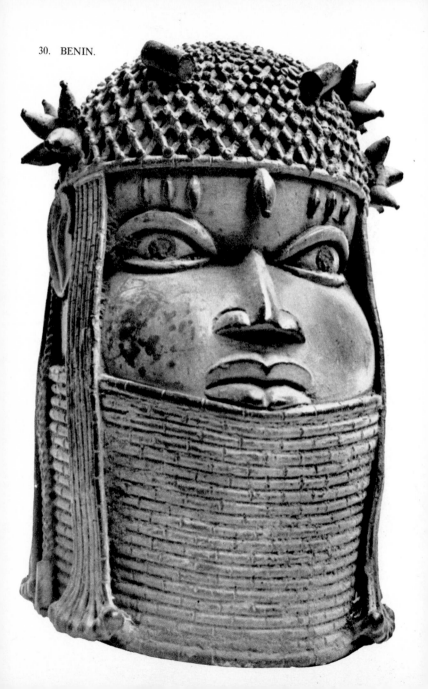

30. BENIN.

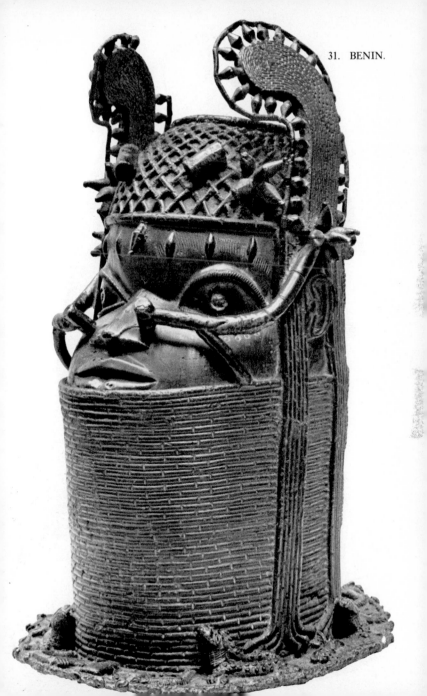

31.  BENIN.

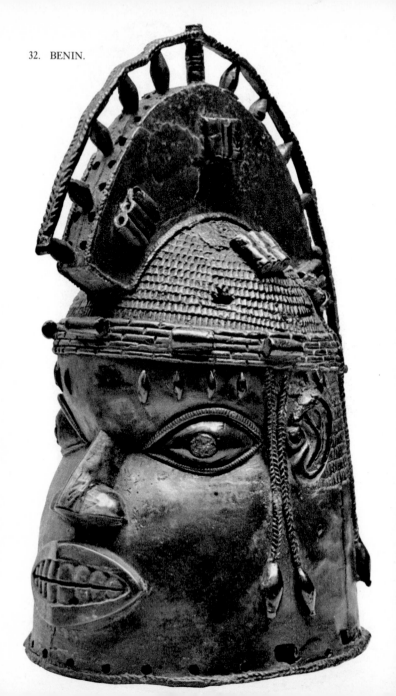

32.  BENIN.

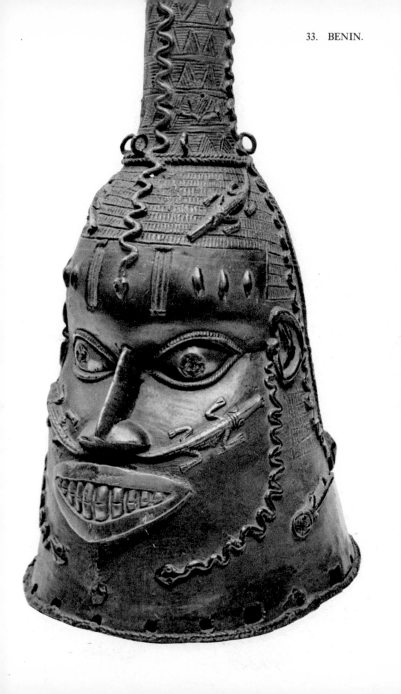

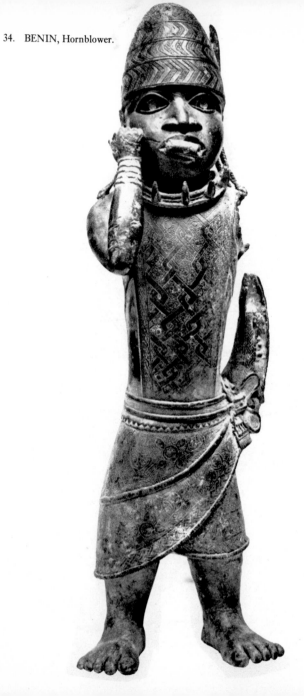

34.   BENIN, Hornblower.

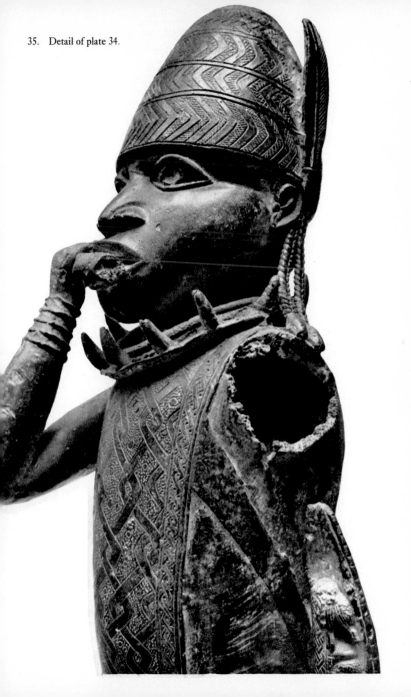

35. Detail of plate 34.

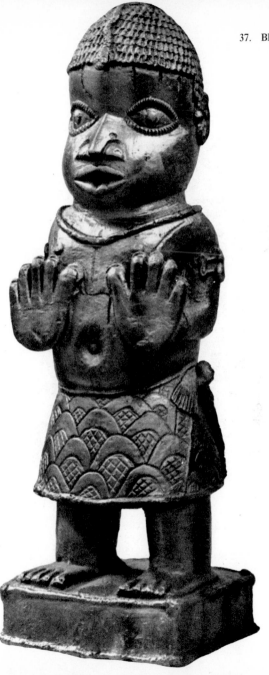

38. BENIN.

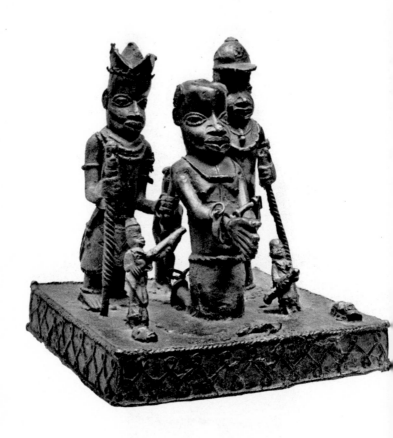

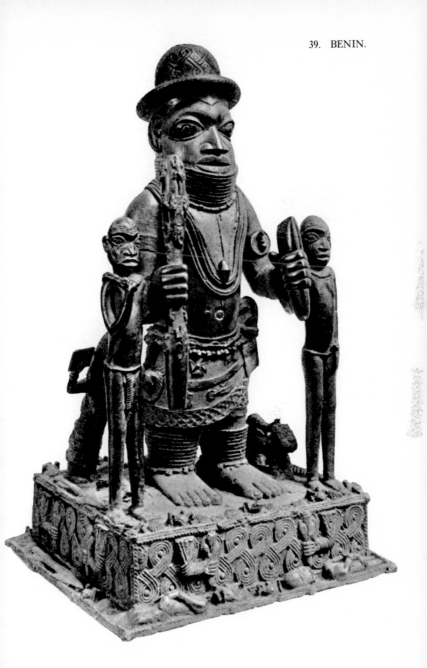

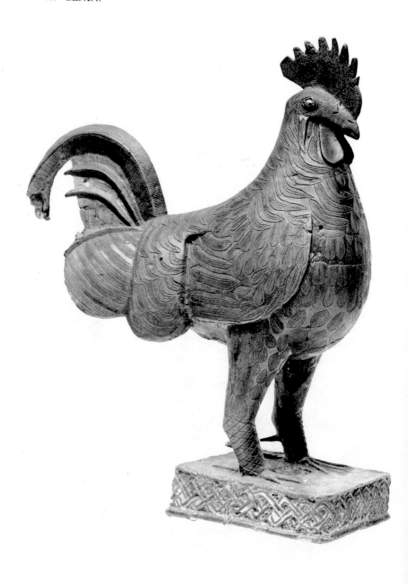

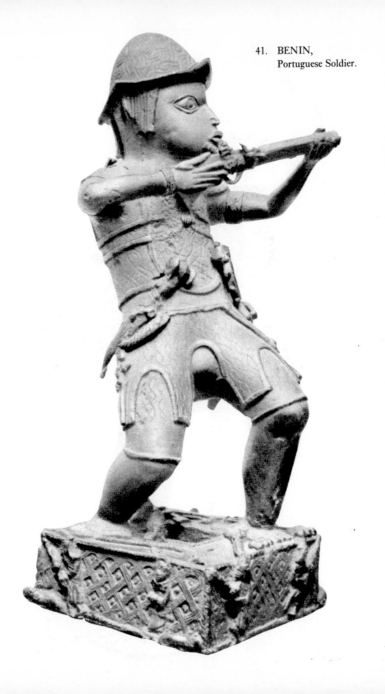

41. BENIN,
Portuguese Soldier.

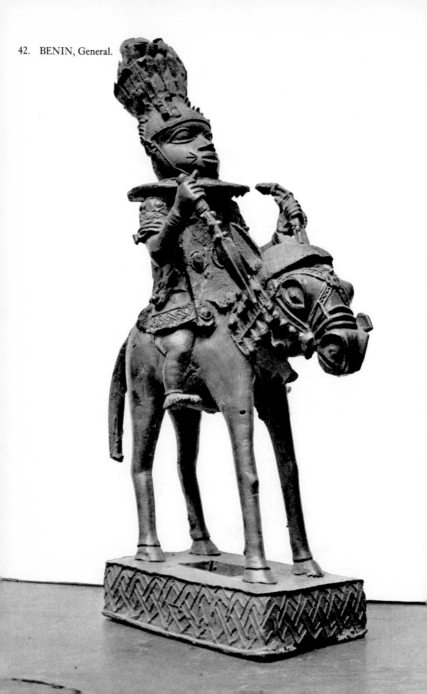

42.  BENIN, General.

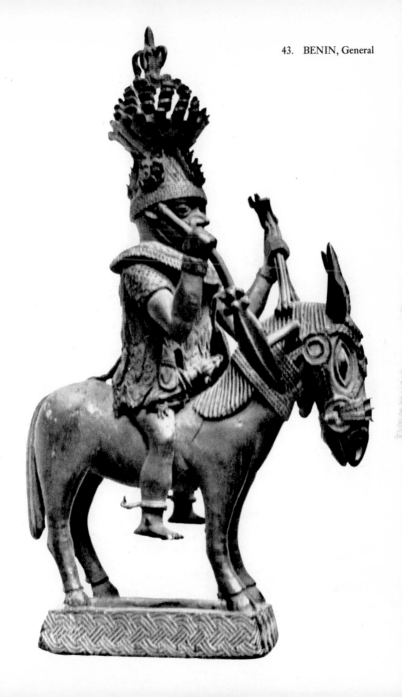

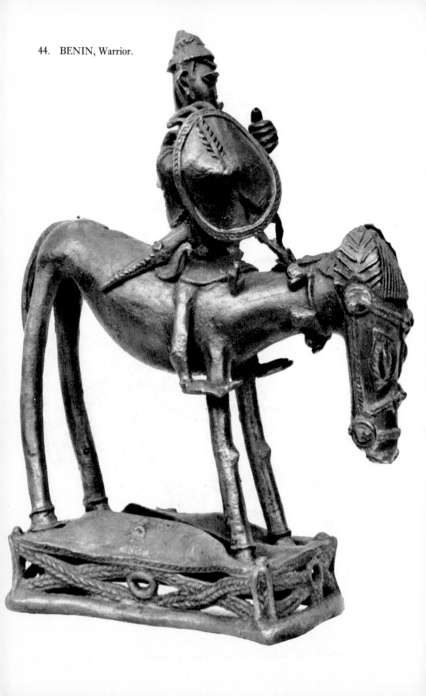

44. BENIN, Warrior.

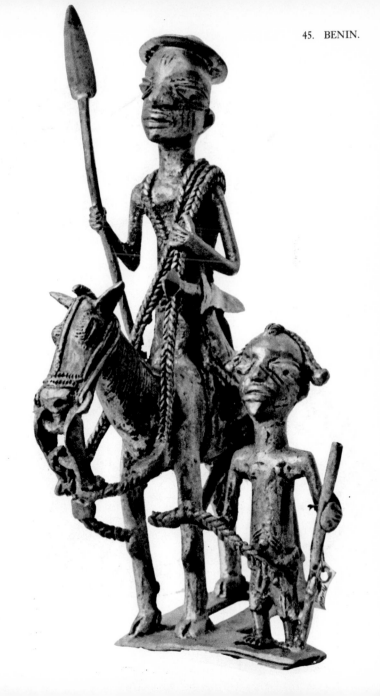

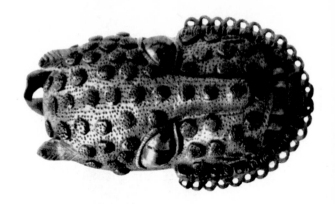

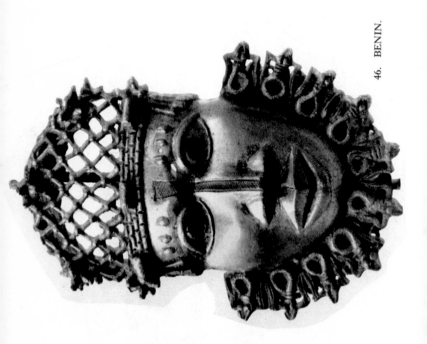

46.   BENIN.

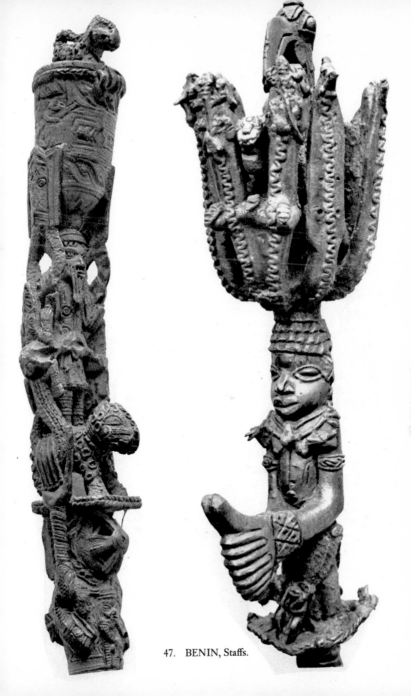

47. BENIN, Staffs.

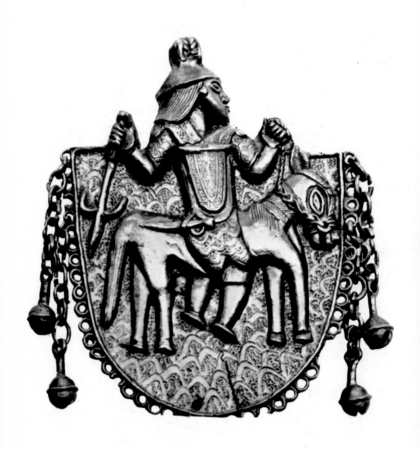

48.   BENIN, Pendant.

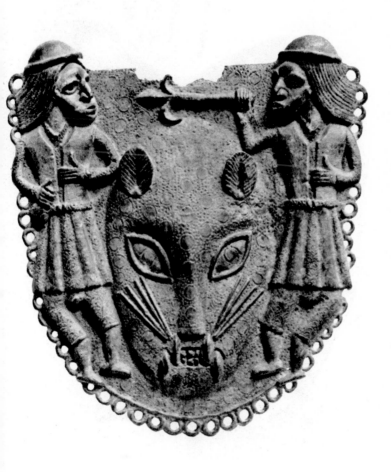

49.   BENIN, Pendant.

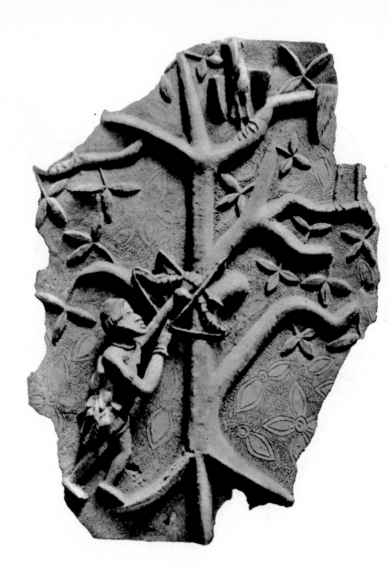

50. BENIN.

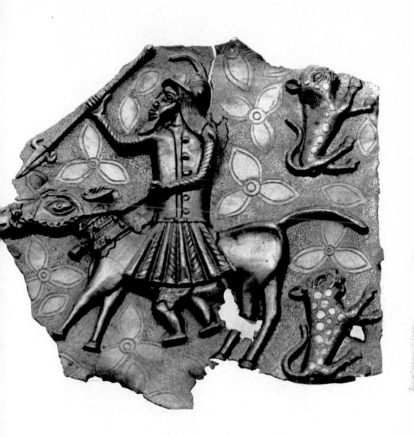

51.  BENIN.

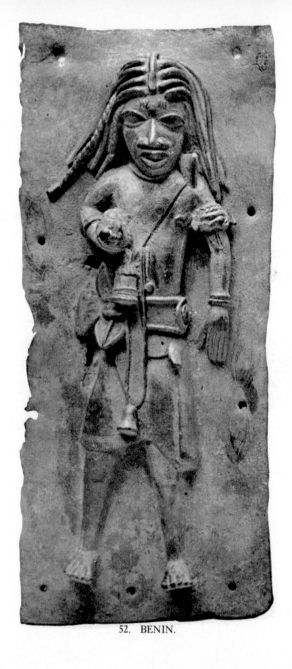

52.  BENIN.

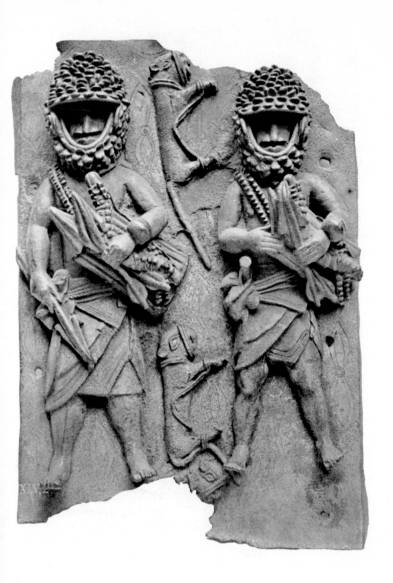

53. BENIN.

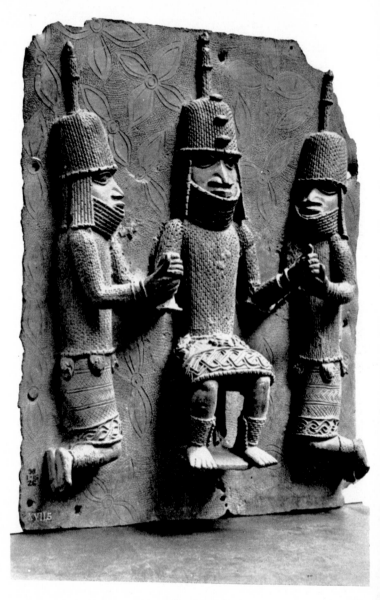

54. BENIN.

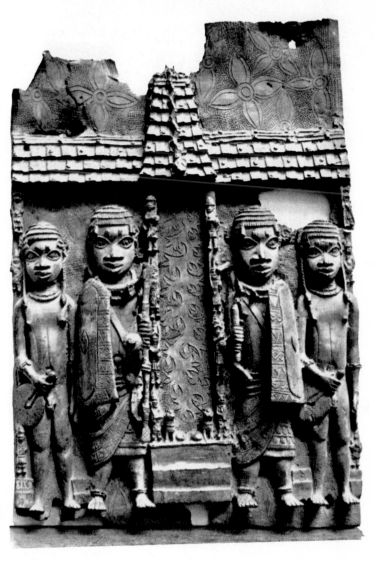

55.  BENIN.

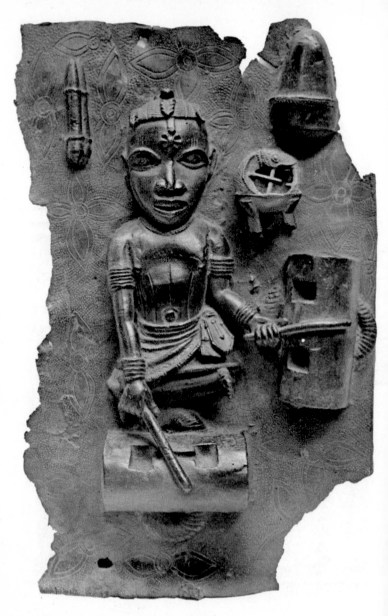

56. BENIN.

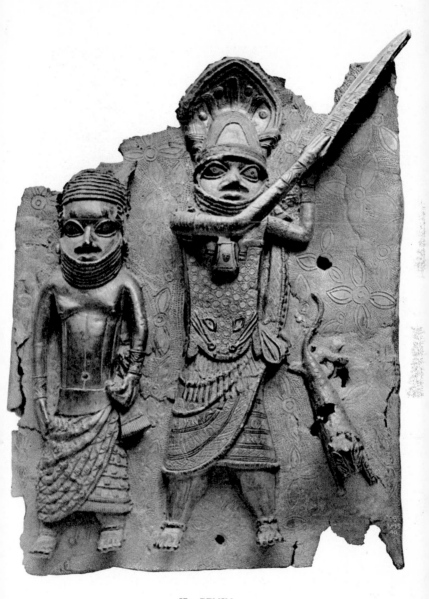

57.  BENIN.

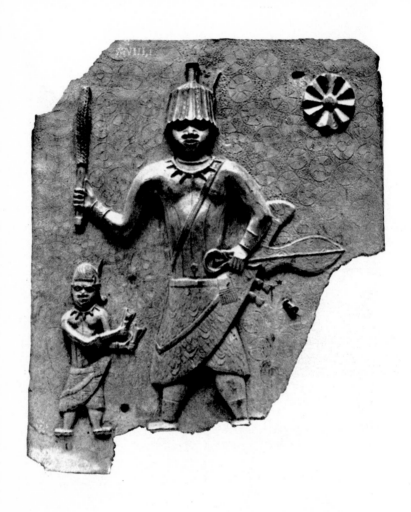

58. BENIN.

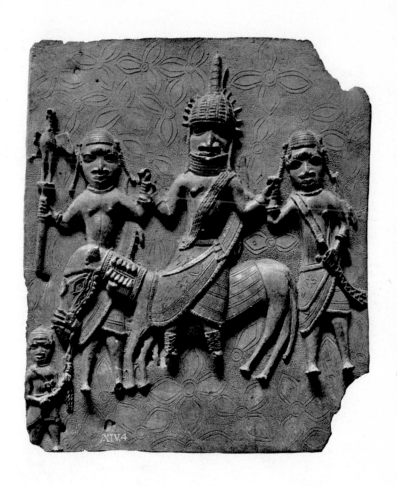

59. BENIN.

60. BENIN.

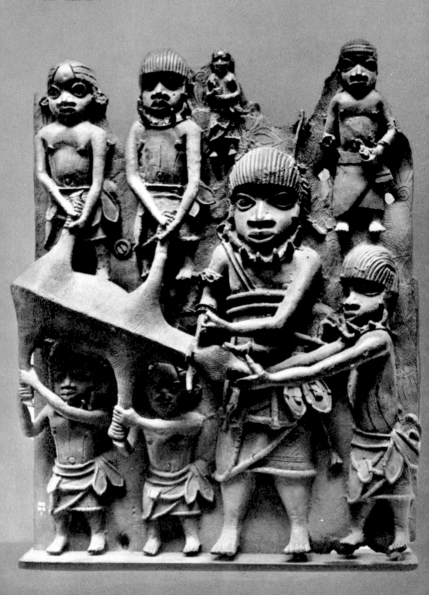

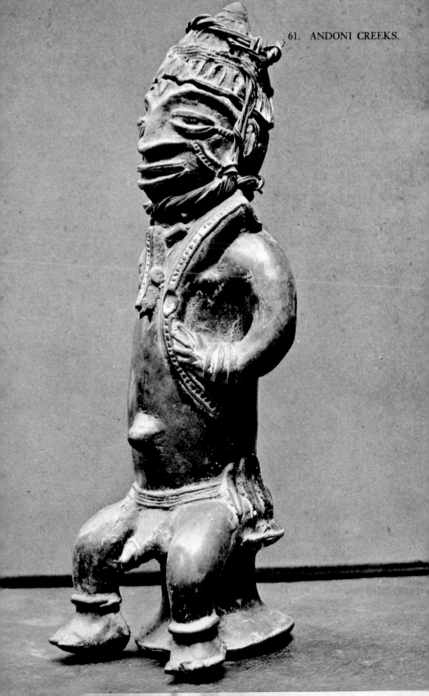

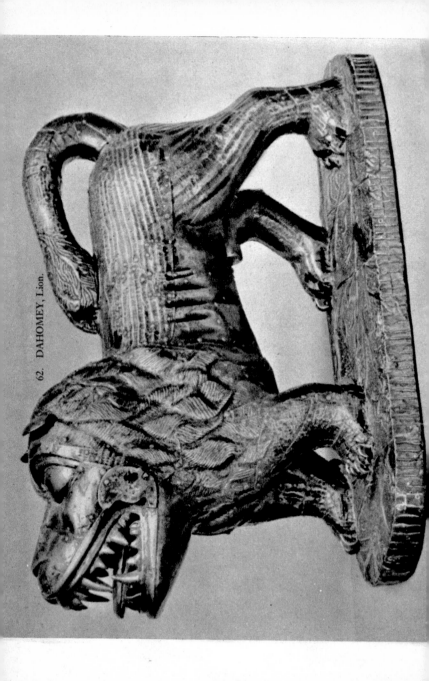

62. DAHOMEY, Lion.